WORKING STIFFS

OCCUPATIONAL PORTRAITS

IN THE AGE OF TINTYPES

MICHAEL L. CARLEBACH

WORKING

SMITHSONIAN INSTITUTION PRESS

Washington and London

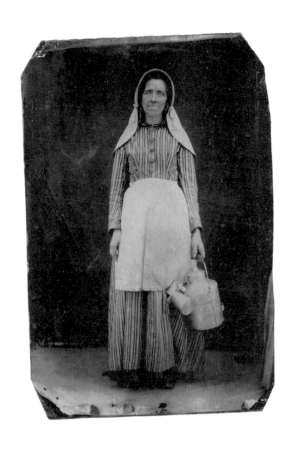

STIFFS

EDITOR: Ruth G. Thomson
DESIGNER: Janice Wheeler

Library of Congress Cataloging-in-Publication Data
Carlebach, Michael L.
Working stiffs : occupational portraits in the age of tintypes /
Michael L. Carlebach.
 p. cm.
Includes bibliographical references and index.
ISBN 1-58834-067-8 (alk. paper)
1. Tintype—United States—History—19th century. 2. Portrait
photography—United States—History—19th century. 3. Working
class—United States—History—19th century—Portraits. I. Title.
TR375.C37 2002
779'.2'097309034—dc21 2002018873

British Library Cataloging-in-Publication Data available

Manufactured in the United States of America
09 08 07 06 05 04 03 02 5 4 3 2 1

∞ The paper used in this publication meets the minimum requirements of
the American National Standard for Information Sciences—Permanence of
Paper for Printed Library Materials ANSI Z39.48-1984.

Captions and credits for the tintypes and daguerreotype used on pages iii,
vi, xiv, and 18 can be found on pages 107, 57, 12, and 35, respectively.

In memory

of

Priscilla Wardwell Carlebach

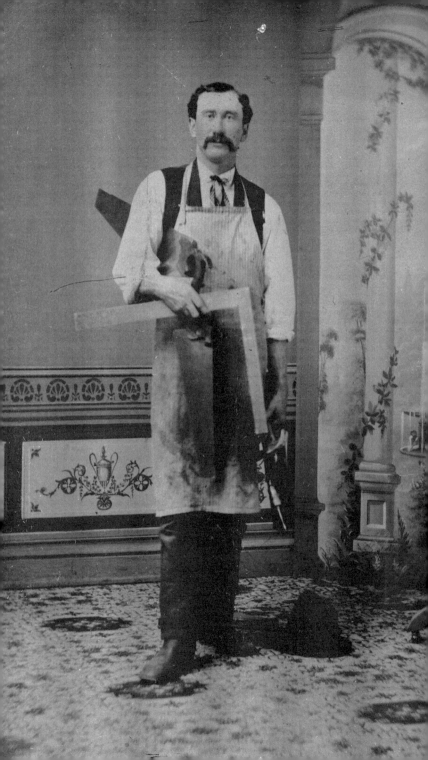

Contents

Acknowledgments

The genesis of this book is a collection of occupational tin-types amassed by Ken Heyman, the renowned photojournalist perhaps best known for his many brilliant collaborations with anthropologist Margaret Mead. Ken is an old friend; he was my mentor when I began taking pictures in the late 1960s, and we have remained close for over three decades. Knowing of my interest in the history of photography, he asked me several years ago if I would be interested in writing about tintypes. I said, "Yes," and this book is the result. It could not have been done without both his generosity and his abiding passion for photography.

I am grateful, too, for the support of many persons at the Smithsonian Institution Press. Mark Hirsch, the acquisitions editor for this project, was especially helpful. His enthusiasm for this project never waned, even when I felt like throwing in one or more towels, and his knowledge of labor history guided my own research efforts. Production editor Ruth Thomson and design manager Janice Wheeler guided

the book from manuscript to bound copy with unerring expertise. And I wish to thank as well Scott Mahler, Emily Sollie, and Andrea Brusca.

Pat Malone of the American Civilization Program at Brown University was also most helpful, especially in the early stages, and his scholarship on the archaeology of industry influenced all the writing here. My wife, the architect and historian Margot Ammidown, was my partner throughout, providing invaluable help from beginning to end.

In addition, I wish to thank Beverly Brannan, curator of Prints and Photographs at the Library of Congress; David Montgomery of Yale University; Marion Rinhart, co-author of *The American Tintype;* Sandra Seitz, associate curator of Rare Books and Manuscripts at the Paterno Library at Pennsylvania State University; Harry Rubenstein of the Smithsonian Institution's National Museum of American History; Anne Cadrette of the American Textile History Museum in Lowell, Massachusetts; and Rochelle Pienn of the Otto Richter Library of the University of Miami. Several social and cultural historians at the Smithsonian's superb National Museum of American History assisted in the identification of tools and professions. Harry Rubenstein, David Shayt, Gary Sturm, Roger White, Cynthia Hoover, and Barry Finn were generous with their time as well as their knowledge, as was James Bruns, director of operations for American Museums and National Programs.

My friend and colleague Rocco Ceo of the University of Miami School of Architecture was especially helpful and supportive. As with my other books for the Smithsonian Institution Press, I was assisted by Roland Joynes and Jerry Taksier; their friendship and expertise in computer-based and photographic imagery were invaluable and greatly appreciated. I also wish to thank Fred Karrenberg, Tom Stepp, and Larry Langner.

Finally, in the summer of 2000 I was most fortunate to be awarded a Max Orovitz grant from the University of Miami, which enabled me to spend several months gathering materials and research without which this book could not have been completed.

WORKING STIFFS

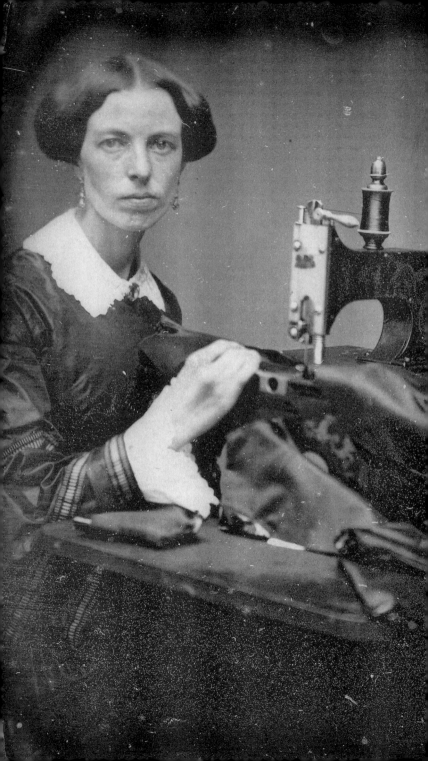

Preface

This book is about working people. In particular, it is about the carpenters, blacksmiths, seamstresses, tinkers, tailors, and others who posed for tintype photographers during the last half of the nineteenth century. We know little more about them. Their names are lost to us, and we have no way of determining precisely where or how they lived. All we know is what we see in the pictures: ordinary working people who chose to be photographed with tools. That they did so, however, is significant, for tools then were endowed with both status and pride. For these sons and daughters of toil, born into a society that still valued making things more than buying and consuming them, manual labor was a legitimate source of respect, if not admiration. Moreover, because the national economy drifted frequently into panic and depression between 1873 and 1896, when most of these pictures were made, steady work of any kind was

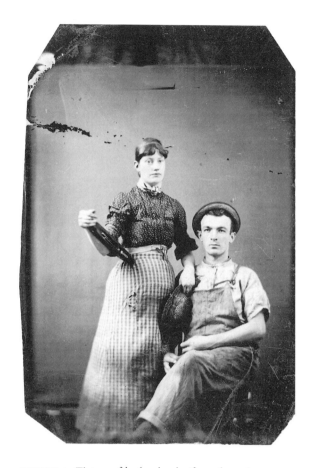

FIGURE I. Tintype of husband and wife textile workers. Courtesy of the American Textile History Museum, Lowell, Massachusetts.

something to commemorate with a picture.[1] The people in these simple, inexpensive photographs were rightly pleased with their skills and with what they did for a living; they were proud of being workers and meant to say so in a photograph.

Although the term "working stiffs" was coined in the first decade of the twentieth century, several decades after most of these photographs were made, it serves as an appropriate title for this book for two reasons. First, the term refers to common workers. It was meant to be neither snide nor derogatory, merely descriptive, and thus fits the people in this book. Men and women who called themselves working stiffs did so with a touch of pride, for the emphasis was always on the working, not the stiff. Equally important, the work itself, though often derided or even entirely dismissed as menial, was likely to require prodigious skill, dexterity, and expertise.

"Working stiffs" connotes the staid old republican virtue of hard work and implies an essential nobility therein, even when the work is unremitting or low paying. The term also implies a kind of worker solidarity and the idea that despite the introduction of "labor-saving" machines and man-

1. On the post–Civil War economy, see Alan Trachtenberg, *The Incorporation of America: Culture and Society in the Gilded Age* (New York: Hill and Wang, 1982), 39–42.

agement's seemingly endless enthusiasm for mechanical and technological solutions to labor problems, real work performed by real people is still vital.

Frank Crampton, the wandering son of a prosperous and socially prominent family in New York City, spent several decades extracting ore and coal from mines across the American West and called himself a working stiff without embarrassment or shame. In gold and silver boom towns like Goldfield, Nevada, Crampton labored side-by-side with "characters from all parts of the world." The men in those hardscrabble mining towns, working stiffs, hard-rock stiffs, and bindle stiffs (not hobos!) who rolled meager belongings into bedrolls when tramping from job to job, from mine to mine, may have been at the bottom of the pay scale, but without them nothing at all could be pried from the earth. Though machines made the work easier, Crampton and his fellow workers often preferred using hand tools, proud of their ability to pluck ore from the rock with little more than their bare hands. "The hard-rock miners and other working stiffs were the foundation and hard core," he wrote. "Without them the mines would have closed down and there would have been no Goldfield."[2]

Pride in humble work still exists, of course, though few

2. Frank Crampton, *Deep Enough: A Working Stiff in the Western Mine Camps* (Denver, Colo.: Sage Books, 1956; Norman: University of Oklahoma Press, 1982), 29, xiv.

workers describe themselves as "stiffs" any more. However apt, the term has lost its panache. Eric Hoellen, a janitor for more than two decades, admitted to Studs Terkel that it was not unusual for "people [to] look down on us." But, he adds, his work with broom, mop, and bucket, as well as that of countless other common laborers, is perfectly honorable. "A ditchdigger's a respectable man," Hoellen said. "A gravedigger's a respectable man. A garbage hauler, he's a respectable man—if he does his job."[3]

The second and more obvious reason for the title of this book is that the people in the images are actually stiff. Exposure times in the heyday of the tintype, which lasted from 1856 to the turn of the century, were much longer than today, sometimes lasting as long as half a minute. To avoid the accidental and unsightly blur, photographers used clamps to keep heads and bodies still and exhorted their customers to remain absolutely motionless. No wonder the sitters sometimes looked a little grim.

Henry Peach Robinson, the renowned Victorian photographer who spent the better part of a lifetime arguing on behalf of art and artfulness in photography, insisted that the only sure way to achieve perfect stillness was to use the dreaded clamp, which he euphemistically called a headrest.

3. Studs Terkel, *Working: People Talk about What They Do All Day and How They Feel about What They Do* (New York: Pantheon Books, 1972), 122.

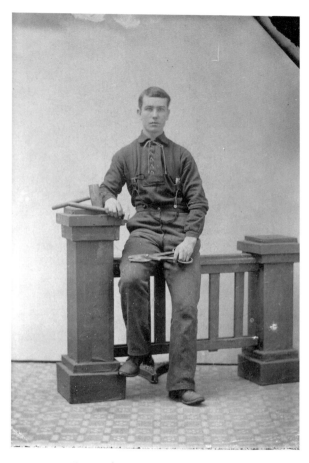

FIGURE 2. Tintype of young man with a mallet, hammer, and tinsnips. Reproduced with the permission of the B. and H. Henisch Photo-History Collection, Special Collections, the Pennsylvania State University Libraries.

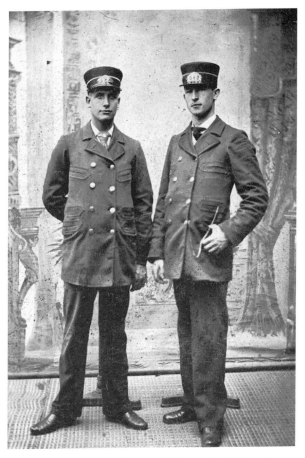

FIGURE 3. Streetcar conductors. Each is standing in front of a neck brace.

"Never mind how much your sitter objects," he told the readers of the British *Year-Book of Photography*.

> Explain that it is indispensable, and that it will give the portrait a better expression. You will have difficulty in persuading him of this; but try the effect of appealing to his good-nature, by telling him that the thought of there being much less chance of his spoiling the picture through moving, and giving you the trouble of taking another negative, ought to send such a glow of happiness through him, that it is certain to appear in his face; and it will.[4]

Mark Twain added his own compelling reason to look into the camera's lens without smiling, but it was not because of head clamps. Due to his extraordinary popularity as both writer and entertainer, Twain was often photographed by amateurs as well as professionals, yet he consistently maintained a grave and sober expression. Late in his life he was asked by a friend why he always seemed serious in pictures. It had nothing to do with his mood at the time or some deep-seated aversion to cameras or photographers, replied the great man. "I think a photograph is a most important document," he said, "and there is nothing more damning to

4. Henry Peach Robinson, "How to Manage Your Sitter," *Year-Book of Photography;* reprinted in *Photographic Mosaics* 2 (1867): 113.

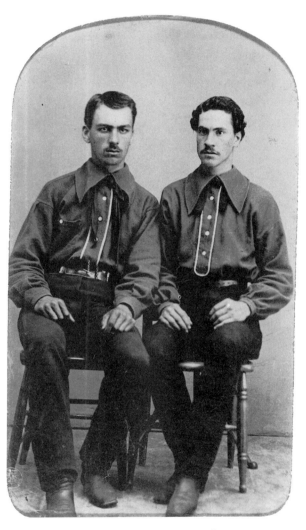

FIGURE 4. Tintype of performers. Private collection.

go down to posterity than a silly, foolish smile caught and fixed forever."[5]

In the early days of photography, working-class people rarely posed for the camera; daguerreotypes and even the first paper prints were well beyond their reach, unless someone else was footing the bill or a sudden windfall made the extravagance of a photographic portrait feasible. Occupational portraits were made in daguerreotype, ambrotype, and carte de visite form, of course, but most were of middle- and upper-class men and women—artisans and professional people. Working stiffs simply had too little in the way of disposable income to spend even a modest amount on a fine, cased daguerreotype or the multiple paper prints made possible by the collodion process. A few nineteenth-century businesses did compile albums of photographs of individual workers, usually in carte de visite format, but these projects were made for the company, not for individual workers.[6] They are, in fact, more akin to traditional group portraits of

5. Elizabeth Wallace, *Mark Twain and the Happy Island*, 2nd ed. (Chicago: A. C. McClurg and Co., 1914), 34.

6. See, for instance, Ronald Filippelli and Sandra Stelts, "Sons of Vulcan: An Iron Workers Album," in *Shadow and Substance: Essays on the History of Photography*, ed. Kathleen Collins (Bloomfield Hills, Mich.: The Amorphous Institute Press, 1990), 105–9; "Lyon, Shorb & Company Photograph Album," *The Western Pennsylvania Historical Magazine* 71, no. 3/4 (July–October 1988): 263–76.

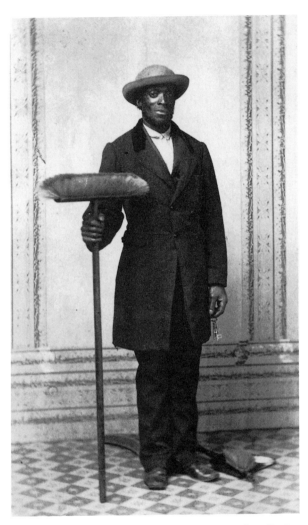

FIGURE 5. Carte de visite of a college janitor. From the collection of Ken Heyman.

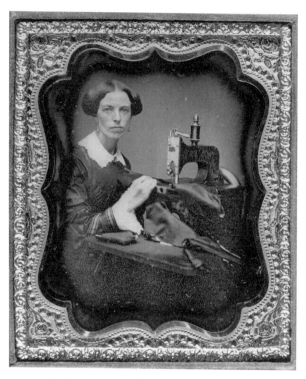

FIGURE 6. Daguerreotype of a seamstress with an industrial model Grover and Baker sewing machine. Courtesy of the Prints and Photographs Division of the Library of Congress.

workers, a common method of visually documenting the work force in certain industries.

Photography, reported the journal of the Photographic Society of London in 1854, is "par excellence *the* scientific amusement of the higher classes."[7] All that changed in 1856 when the tintype process was invented. Initially called ferrotypes or melainotypes, tintypes were cheap, fast, and easy to make, and they became enormously popular with working stiffs and others who had been left out of the great visual revolution begun by Louis-Jacques-Mandé Daguerre in 1839.

With a very few exceptions, the most common reaction of historians to tintypes has been undisguised contempt or, at best, indifference.[8] The obvious lack of artistic method and intention of a legion of anonymous tintypists combined

7. *The Photographic Journal,* January 21, 1854; cited by Alan Thomas, *Time in a Frame: Photography and the Nineteenth-Century Mind* (New York: Schocken Press, 1977), 12.

8. The most thorough history of tintypes is Floyd Rinhart, Marion Rinhart, and Robert W. Wagner, *The American Tintype* (Columbus: Ohio State University Press, 1999). See also Reese V. Jenkins, *Images and Enterprise: Technology and the American Photographic Industry, 1839–1925* (Baltimore, Md.: Johns Hopkins University Press, 1975), and Robert Taft, *Photography and the American Scene: A Social History, 1839–1889* (New York: Macmillan, 1938; New York: Dover Publications, Inc., 1964).

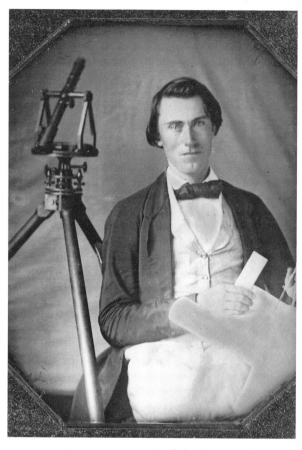

FIGURE 7. Daguerreotype portrait of a land surveyor. Courtesy of the Prints and Photographs Division of the Library of Congress.

with disdain for the subjects of tintypes—usually working-class people—did little to inspire writers on photography, and for a century the process and the product remained unsung and unremembered. Even contemporaries had trouble with tintypes. Edward L. Wilson, editor of both *The Philadelphia Photographer* and *Photographic Mosaics*, admitted in 1868 that his readers frequently urged him to run articles on ferrotypes. He knew that the process was widely used but thought that most of his readers were "forced to make this class of picture against their will" due to tintypes' enormous popularity. Though not willing to dismiss them altogether, Wilson was not the least bit sanguine about the significance of tintypes, since they seemed so artistically barren. "We hope . . . for a better future for photography than such pictures would predicate," he wrote in an editorial comment appended to George H. Fennemore's article "Collodion Positives." "It should be the effort of all good photographers to strive to improve and elevate their art by making good and careful work, even though the price be low."[9]

This book seeks to reappraise tintypes, not by arguing for their inherent artistic merit, but by examining a small portion of the world they illuminated. At a time when a depersonalized factory system run by production and efficiency experts was beginning to dominate American indus-

9. *Photographic Mosaics* 2 (1868): 57–58; see also *The Philadelphia Photographer* 4, no. 41 (May 1867): 137–40.

try and culture, ferrotyped occupational portraits stressed individuality and the essential dignity of work. Most of the men and women depicted here were part of a dwindling army of self-employed and small-scale entrepreneurs, artisans, and journeymen, and the majority of the pictures were probably made by itinerant photographers in rural America where the process was especially popular. Moreover, the person operating the camera was likely to be as much a working stiff as the unsmiling person standing in front of it. The hand of the photographer is muted throughout: these are strictly anonymous portraits of unknown persons, and whatever personal messages they conveyed to family or friend are now forever lost. Still, they are not without meaning, for to paraphrase historian Alison Nordstrom, these simple portraits on iron plate have the look of history and feel like memory.[10]

After the Civil War, a veritable industry grew around the tintype as working-class photographers untrained in the social niceties and oblivious to the sacred requirements of art trained their cameras on a new generation of sitters, ordinary workers. Much to the dismay of established photographers such as the great Boston daguerreotypist Albert Sands Southworth, tintypists swarmed into the profession

10. Alison Nordstrom, "Voyages (per)Formed: Photography and Travel in the Gilded Age" (Ph.D. diss., Union Institute, 2001), 35.

from "the accustomed labor of agriculture and the machine shop, from the factory and the counter, from the restaurant, the coach-box, and the forecastle."[11] Not only did they generally shun the traditional photographic apprenticeship, but also the newcomers seemed wholly disinterested in creating art or setting and maintaining high prices. Their work was derided by the photographic elite and, until very recently, ignored or belittled by historians, but it has a story to tell.

11. Albert S. Southworth, "An Address to the National Photographic Association of the United States. Delivered at Cleveland, Ohio, June 1870," *The Philadelphia Photographer* 8 (October 1871): 320.

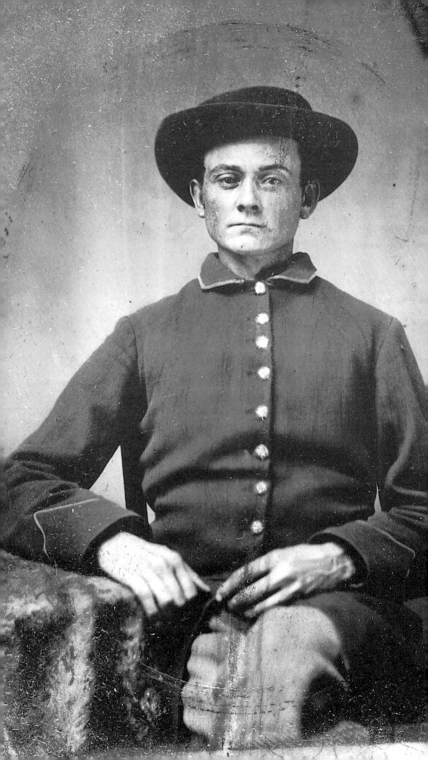

Tintypes and the Democratization
of Photography in
Nineteenth-Century America

At the end of the nineteenth century, William Latour, president of the Missouri Photographic Association, spoke to his peers—each one a consummate professional—at their annual meeting. Latour and the others were more than a little dispirited. The members, who viewed themselves as a new kind of artistic elite, were highly disturbed by the proliferation of photographers who seemed more interested in commerce than art, in quantity rather than quality. To make matters much worse, the upstarts eagerly and without the slightest apology appealed to a legion of common folk, people whose very presence threatened the delicate economic and artistic underpinnings of the profession. "I have been an ardent and enthusiastic worker for nearly forty years," Latour told his friends, watching "with much interest the kaleidoscopic change from the staid, old daguerreotype to the wonderfully, marvelous, and artistic productions of to-day." But the present "debauchery and

prostitution" of the profession threatened to ruin every-
thing, dropping prices so far that all that remained was "the
gaunt spectre of the past."[1]

Latour's overheated eloquence was not unusual, for
such imprecations had been uttered at regular intervals
since the invention of photography in 1839. Not many went
so far as the French poet and critic Charles Baudelaire, who
wrote in a famous fit of melancholy in 1859 that the new
medium was the last refuge of those who lacked the skill to
be painters, but there was consternation nonetheless.[2] The
mystifying mechanical and chemical aspects of photogra-
phy seemed to Baudelaire and many others increasingly to
crowd out aesthetic considerations, yielding images note-
worthy only for a certain manual finesse on the part of the
operator combined with the automatic precision of lenses.
Although admitting that it was at least theoretically possible
to create art with the camera, the French painter-turned-
photographer Louis Desiré Blanquart-Evrard complained
that few of his fellow photographers possessed true "artis-
tic feeling." Instead, he was surrounded by persons "whose

1. William Latour, "Address on Photography," *The Professional
Photographer* 1, no. 8 (September 1896): 381.

2. Lois Boe Hyslop, *Baudelaire: Man of His Time* (New Haven: Yale
University Press, 1980), 63–65.

success is owing to mere scientific knowledge and manipulatory skill."[3]

In the United States, criticism of photography focused on two seemingly unassailable facts. First, many photographers seemed more interested in making money than in making art; second, and equally disturbing, their choice of subject matter showed an appalling lack of discrimination and taste. The flood of images made with cameras seemed just that, a messy torrent, and critics bemoaned the profession's lack of regard for the sublime. "There are those who with a love for the beautiful are always zealous and watchful for its advancement and growth," wrote H. J. Rodgers, a successful studio photographer from Hartford, Connecticut. But these knowledgeable few—including himself, of course—were badly outnumbered. "There are *hosts* of others who care little in relation to the dignity, beauty, or elevation of the art," he continued, so long as their pecuniary ideal is reached."[4]

3. Louis Desiré Blanquart-Evrard, *On the Invention of Art in Photography,* trans. Alfred Harral (London: Sampson Low, Son and Co., 1864), 7; facsimile edition in Robert A. Sobieszek, ed., *The Collodion Process and the Ferrotype: Three Accounts, 1854–1872* (New York: Arno Press, 1973).

4. H. J. Rodgers, *Twenty-three Years Under a Skylight* (Hartford, Conn.: H. J. Rodgers, Publisher, 1872; New York: Arno Press, 1973), 14.

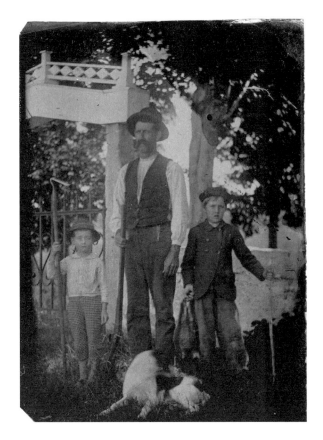

FIGURE 8. Tintype of a farmer and his sons. From the collection of Ken Heyman.

Those who derided photography were driven to new levels of invective by the introduction in 1856 of the tintype. This direct positive on a thin sheet of black- or brown-lacquered iron (not tin) sold for a song and required

little in the way of training to produce. For about twenty-five dollars, less with homemade or used equipment, would-be photographers could cobble together a primitive outfit—camera, lenses, and the necessary developing and fixing materials—and hang out a shingle. Neither the photographers nor their clients cared much about the creation of art; tintypes were not made to be exhibited or reproduced on the pages of a high-toned magazine. The goal of most tintypists was far simpler: rapid turnover and a modest profit, while all the sitter desired was a simple likeness to keep or to give away. For common laborers and their families, the opportunity to join the ranks of those who owned pictures of family and friends was momentous. Edward M. Estabrooke, a tintypist and author of a history and manual of tintyping, spoke of those in the "humbler walks of life" who could at last gratify that universal passion, "the craving to possess some memento of the passing moment in this world of change."[5]

In February 1860, E. K. Hough, a photographer in Union, South Carolina, complained bitterly in Charles Seeley's *American Journal of Photography and the Allied Arts and Sciences* that the profession he loved was being overrun with shoddy operators without the slightest love or even

5. Edward M. Estabrooke, *The Ferrotype and How to Make It*
(Cincinnati, Ohio, and Louisville, Ky.: Gatchell and Hyatt, 1872), 23.

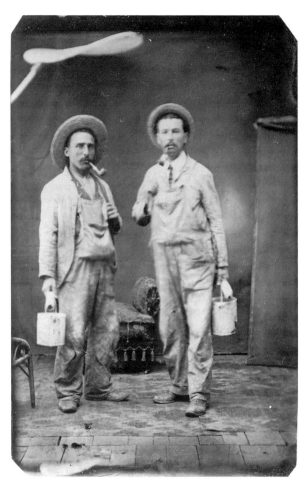

FIGURE 9. Tintype of housepainters, showing crude light baffle. Reproduced with the permission of the B. and H. Henisch Photo-History Collection, Special Collections, the Pennsylvania State University Libraries.

appreciation for art, and usually with no fixed address. As a result, far too many Americans now believed that all "photographists" were in it purely for the money. Having "no ambition or active enterprise, and lacking energy and skill to maintain a manly competition in beauty and quality of workmanship," these rootless adventurers descend swiftly to the level of "pedlars of matches and brooms" undercutting each other's prices and "living on the smallest possible profits."[6] Hough's complaint seemed aimed especially at the growing number of nomadic photographers who traveled about the country in photo-wagons or plied the rivers in floating studios, and whose favorite picture was the lowly tintype.

Everything about the tintype offended the photographic establishment. Often sold with little or no adornment, not even the filigree brass matte used for daguerreotypes and ambrotypes, just a simple paper envelope, tintypes seemed hopelessly crude. The emphasis was nearly always on cheapness and speed instead of aesthetics, and the working-class clientele seemed as blissfully dismissive of the requirements of art as the photographer. For those who attempted to convince each other and the world that

6. E. K. Hough, "Photographic Artists," *American Journal of Photography and the Allied Arts and Sciences* 2, no. 20 (March 15, 1860): 307, 308.

photography was or at least could be more art than commerce, the tintype seemed the ultimate insult. "The photographer . . . is anxious to do whatever elevates and ennobles his art," wrote an exceedingly bothered practitioner to *The American Journal of Photography* in 1860. The problem was that far too often dishonorable business practices and sloppy methods led to inferior results and so gave the entire profession a bad name. The good and proper photographer, he wrote,

> charges a fair price for his pictures, and does not try to undersell his neighbor. He is never found during work hours or after dinner standing at his own door smoking or chewing. . . . He is always courteous and polite to sitters, and does not chuck young ladies under the chin, instead of asking them to raise the head. He does not consider it necessary to eat his dinner with stained fingers, in order to let people know that he *is* a photographer and is very busy.[7]

Though much of the criticism was ostensibly about the woeful lack of artistic training and manners among tintype photographers, the real culprit was the working-class character of the business. The unmistakable stink of snob-

7. "The Photographer As He Is and As He Should Be," *The American Journal of Photography* 2, no. 15 (January 1, 1860): 228.

bery and pretension pervades much of what was written about tintypes. Mr. Rodgers of Hartford, attracted by an inexpertly hand-lettered sign that promised "twelve tin-types for twenty-five cents" tacked over a doorway in a poor section of town, ventured into "the artist's inner sanctum." What he found there confirmed his belief that photography was in danger of sinking into artless mediocrity, or worse. Like most urban studios, this one was located on the top floor to take advantage of the extra illumination provided by a skylight. Rodgers slowly navigated his way along "dirty, dismal halls, and up squeaking, dilapidated stairs" until he came at last to the studio, which was crowded to overflowing with customers who reminded him of the weird and pitiable inhabitants of a circus sideshow. He made no secret of his contempt for the people in that small studio, none of whom, presumably, could have afforded the fancy portraits he made for a living.

> One blear-eyed, bloated, ale beer keg shouted at the top of his voice (which reverberated like a fog whistle at sea), "Ladies and gents, pass right up stairs. We warrant you satisfaction or your money refunded." Just at this time two individuals rushed through the crowd up to the show case. One said in a rather impatient and "out of breath" style, "I say! look-a-here! Are you - is the boss doing anything jest now? I've come to get a five-cent picter tuk. I want it done rite now, the hull figger, geest zackly as

I be. Now, I say if you git a good un, I'm coming to git a big job
done; twenty-five cents worth; then I'll have on my best
clothes."[8]

The difference between photographers who disgraced the
profession, like the owner of the dingy establishment just
described, and those who "were ornaments shining
brightly" was for Rodgers purely one of breeding and
class. Studios that specialized in cheap tintypes catered to
the "ignorant and illiterate" and the "poorer and more
faulty the picture in a purely artistic point of view, the bet-
ter they like it." It was inconceivable that such people
would ever be able to grasp the niceties of the pristine art
photographs he made. "To talk about the beauties of ex-
pression or emotion to this class," he wrote, "would be like
throwing beautiful gems and lovely pearls in the midst of a
drove of brewery hogs."[9]

The *American Photographic Almanac,* an annual com-
pendium of articles from *Humphrey's Journal,* both edited
by the redoubtable John Towler, who in addition to his ed-
itorial duties was a professor of mathematics and modern
languages at Hobart College and dean of the faculty at
Geneva Medical College, was usually far more accepting of

8. Rodgers, *Twenty-three Years Under a Skylight,* 215.

9. Ibid., 217, 150.

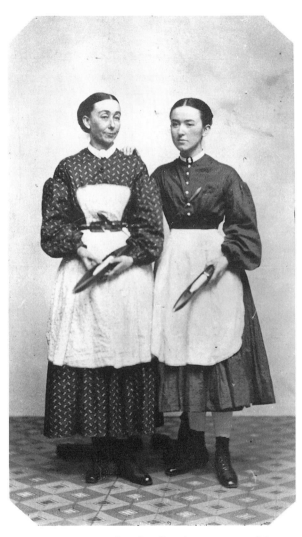

FIGURE 10. Tintype of textile mill workers. Courtesy of the
American Textile History Museum, Lowell, Massachusetts.

tintypes and those who made them.[10] Still, Towler reported in 1865 that tintypes had two basic flaws. The first was unavoidable. Like daguerreotypes and ambrotypes, tintypes are laterally reversed, rendering them "unfit for the practical representation of landscapes or compositions of any kind whatever." Signs and paintings all appear backwards, making them unsuitable, not to mention unreadable. The same might be said for tintype portraits, of course, but sitters rarely noticed or cared about the reversal. Besides, in the case of occupational portraits, in which right- or left-handedness might well be an issue, the photographer could easily make a more accurate image by some studio sleight of hand. "When soldiers in their accoutrements, artisans with their tools, or artists with instruments are to be represented, the impression can be remedied by fixing the tool or instrument in the left hand, when it belongs to the right, during the time of posing."[11]

The second flaw, however, was more serious. Towler suggested that the speed and ease with which the tintype

10. Robert Taft, *Photography and the American Scene: A Social History, 1839–1889* (New York: Macmillan, 1938; New York: Dover Publications, Inc., 1964), 166.

11. "How to Take a Melainotype, or Ferrotype," *American Photographic Almanac* (1865): 36. This article was reprinted with minor editorial changes as "The Ferrotype" in the *American Photographic Almanac* (1868): 47–48.

was made "conferred upon it the odium of vulgarity, similar to that of paste to diamonds." He admitted that nine out of ten tintypes could not "be distinguished from the reality [they] represent." But both their accuracy and obvious popularity were entirely beside the point. The cheapness of the product attracted cheap clients; this made the tintype's low cost "a vulgar fault."[12] That shortcoming could not be fixed. Printed on inexpensive sheets of iron and requiring little labor, tintypes opened up a whole new market to photographers simply on the basis of their cost. The popular appeal of inexpensive pictures would not go away, of course, but it has bedeviled the artistic elite since the age of the tintype.

Tintype business boomed during the Civil War, and Towler's magazine noted the change. As early as August 1, 1861, just months after Southern artillery opened fire on Fort Sumter in Charleston harbor, *Humphrey's Journal* reported that trade in tintypes remained strong since the inexpensive little pictures were easily made to fit in keepsakes such as lockets, breast-pins, and even rings. And the January 1, 1862, issue noted that tintypes were the "favorite plates among camp-following photographers" because of their durability. "Now a picture on glass [an ambrotype] can be accidently dropped and smashed, but whoever heard

12. Ibid.

of smashing a Melainotype?" A vigorous trade developed in tintypes, spurred by the cooperation of the Post Office and the presence of a host of itinerant photographers who were especially active among the Northern armies. "The photographer accompanies the army wherever it goes," Towler reported in February 1862, "and a very large number of soldiers get their 'pictures' taken and send them to friends." The home folks naturally return the favor, "and in this way an immense transportation business has been done by the Post Office."[13] Increased demand and vigorous competition between the two main producers of tintype plates lowered the price of individual pictures even further. *Humphrey's Journal* reported in 1862 that the prices charged for melainotype plates was "reduced to a very low figure," so low, in fact, that the price seemed to defy competition.[14]

Many soldiers posed with weapons, usually a rifle held casually, a pistol tucked into a waistband, or both; officers often held or wore a sword. Whatever their prior work ex-

13. "The Melainotype," *Humphrey's Journal* 13, no. 7 (August 1, 1861): 112; "The Melainotype," *Humphrey's Journal* 13, no. 17 (January 1, 1862): 272; "Photography in the Army," *Humphrey's Journal* 13, no. 20 (February 15, 1862): 319.

14. "Iron Plates," *Humphrey's Journal* 14, no. 16 (December 15, 1862): 208. See also Reese V. Jenkins, *Images and Enterprise: Technology and the American Photographic Industry, 1839–1925* (Baltimore, Md.: Johns Hopkins University Press, 1975), 37–45.

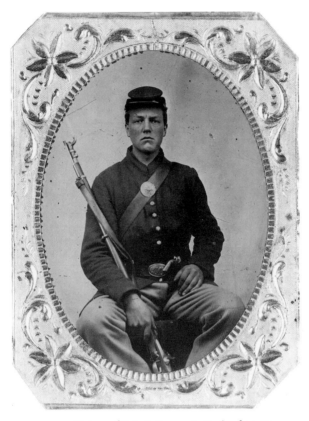

FIGURE 11. Tintype of Private George A. Stryker from New York. Courtesy of the Prints and Photographs Division of the Library of Congress.

perience—as factory hand or farmer, store clerk or crafts-man—they each sought an image that conveyed their present military vocation. The uniform alone did that to some extent, of course, but many soldiers added a weapon

(sometimes supplied by the photographer) for emphasis and accuracy. These were, in effect, occupational portraits of men most of whom fully intended to return some day to their previous line of work. After the war was over, some of them must have posed again, this time holding a simple tool, creating a far more traditional and benign occupational portrait.

Civil War soldier portraits constitute a significant departure from the best-known photographs made during the war, the remarkable collection of views compiled primarily by photographers working for Mathew Brady and, later in the war, Alexander Gardner. Brady's men and the others set out to visually record the war, to capture every aspect of the conflict that could be photographed (battle scenes were out of the question), and thereby to create a vast, unimpeachable, and, they hoped, remunerative visual narrative of armed conflict. The use of glass-plate negatives and the wet-plate process made possible the production of countless paper prints that were sold to both private citizens and the government. The energetic marketing of these images, including their distribution to illustrated newspapers and magazines, made them public documents. In time, photographs such as "Home of the Rebel Sharpshooter," made by Gardner and Timothy O'Sullivan shortly after the battle at Gettysburg, were reproduced and exhibited so often that they achieved the status of cultural icons.

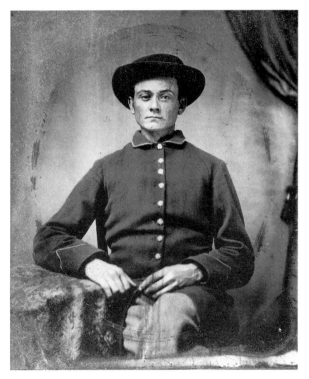

FIGURE 12. Tintype of an unidentified Civil War soldier.
Private collection.

It was not so with the portraits of common soldiers.
These images were intended to please and perhaps to reas-
sure the folks at home, and whatever history they furnished
was intensely personal and private. The soldiers and their
families back home felt a kind of moral obligation to have
those pictures made. As photographer James F. Ryder re-
membered it, in the early days people took portraiture ex-

tremely seriously. "It was more the parents having like-nesses taken for the children, a matter more seriously con-sidered; something more in the way of duty, possibly a last duty—certainly a sacred one—from parents to children, a legacy of love."[15]

"Enclosed I send you my likeness," wrote John Henry Pardington, a private in Company B, Twenty-fourth Michigan Volunteers of the famous Iron Brigade, to his wife, Sarah. "They say it is . . . firstrate. . . . But my eyes I think they are to small." Pardington explained that he and a friend, James McIlheny, visited the photographer together, and they posed similarly. "We are takeing it at (Parade rest)," he wrote, "how we stand on Parade dress." No record survives of Sarah's reaction to the portrait, but ten days later, on March 14, 1863, John wrote again and told her how much he cherished the photograph she had sent him. "Sarah I have Put a little Pocket in that Blue flannel shirt right By my heart and there you and Baby lays night and day. (That is the locket) the one you sent me last."[16] John Pardington was killed just a few months later, on the first

15. James F. Ryder, *Voigtlander and I in Pursuit of Shadow Catching* (Cleveland, Ohio: Cleveland Printing and Publishing Company, 1902), 85.

16. Coralou Peel Lassen, ed., *Dear Sarah: Letters Home from a Sol-dier of the Iron Brigade* (Bloomington: Indiana University Press, 1999), 86, 88.

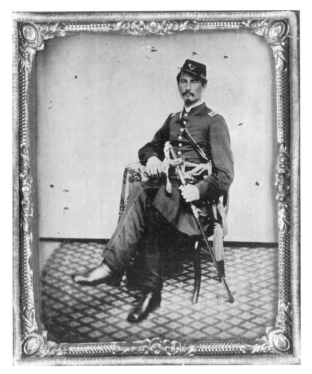

FIGURE 13. Tintype of an unidentified Union officer. Courtesy of the Prints and Photographs Division of the Library of Congress.

day of fighting at Gettysburg. Neither his body nor that cherished locket was ever found.

The Civil War did little to enhance the reputation of tintypes among the elite who still grumbled about their tastelessness and the dreadful cheapening of art, but working-class people were nonplused, for the war made the little pictures an integral part of the domestic scene. It made no

difference what the swells said or how much disdain they felt for the process. Photographer William Heighway, a regular contributor to photographic publications, remarked with confidence in 1881 that although it was "the fashion to sneer at the picture on iron," as had been the case with the carte de visite, criticism of the tintype will "be less loudly, and less confidently uttered ere long."[17] Eventually, there was indeed grudging acceptance of tintypes by the profession, not in terms of their artistic merit, but as occasionally useful and moderately profitable alternatives to paper photographs. In Philadelphia, writer and photographer A. K. P. Trask and several others established the Ferrotypers' Association of Philadelphia in January of 1870, and the minutes of their meetings were regularly published for the next several years in Edward L. Wilson's *The Philadelphia Photographer*. Trask went on to publish a popular handbook on tintypes, *Trask's Practical Ferrotyper*.

Scovill and Adams's popular guide to the practice and business of tintyping noted the change in attitude in the professional ranks. Though always popular, tintypes had been "much retarded by a jealous feeling among photographers, who have tried to degrade it and to 'kill' it." The problem was that tintypes threatened the delicate pricing

17. William Heighway, "The Ferrotype—How It Is Made," *The Saint Louis Practical Photographer* 5 (March 1881): 81.

structure of studio photography. Because tintypes could be made so inexpensively, "photographers feared they would be ruined by the introduction of a cheaper picture." The prospect of price wars and other threats to the photographic bottom line generated intense discussion and numerous attempts to root out those who would undercut the so-called fraternity. In 1886, for instance, photographers in Minneapolis and St. Paul, Minnesota, banded together to fight a single studio that dared to offer cabinet photographs for two dollars less than the going rate. According to the *St. Paul Daily Pioneer Press,* the miscreant was undeterred and promised to "carry on the war at all hazards," a typical reaction to the anticompetitive bluster of the high-priced galleries.[18]

Since they could not make tintypes go away altogether, photographers who specialized in turning out pricey portraits and the occasional ethereal landscape simply ignored the process. In any event, the prices and ambience at fancy urban studios discouraged even casual inquiries from working-class clientele. But it was a different story for others, particularly photographers who worked in rural areas. In an article written for *Photographic Mosaics* in 1884, R. W.

18. *The Ferrotyper's Guide* (New York: The Scovill and Adams Company, 1896), 5–6; "The Photograph War," *St. Paul Daily Pioneer Press,* January 29, 1886, 7.

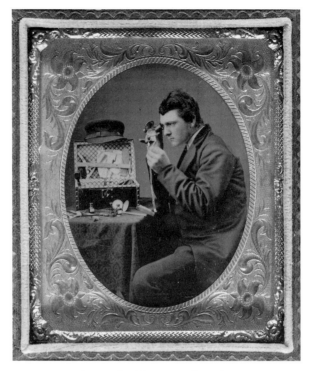

FIGURE 14. Tintype of an itinerant watch repairman. Reproduced with the permission of the B. and H. Henisch Photo-History Collection, Special Collections, the Pennsylvania State University Libraries.

Hubbell contended there was no easy, pat answer to the question of whether or not to make tintypes; rather "circumstances" made all the difference. "If a man has enough photo-work to keep him busy," he wrote, "then tintypes are only a detriment to his work; but if he has *not*, he will in most cases need to take tintypes to help fill his purse." He

added that when clients needed pictures right away, tintypes were ideal since paper prints such as the popular cabinet card were comparatively labor intensive and time consuming due to the intervening steps of producing a negative on glass and then carefully printing, retouching, and mounting the final paper print.[19]

In the end, though, Hubbell reasoned that the most compelling reason to make tintypes lay in their low price. If a photographer chose to deal with people without much in the way of disposable income, the tintype could mean the difference between economic success and failure. After all, in small towns and villages "there is a large class of customers who want pictures, but who will not pay the price of a good photo," Hubbell continued with undisguised condescension and venom, and tintypes suited both their needs and their pocketbooks.

> When a big rural chap comes into your room, and prices your cabinets, you tell him six dollars per dozen, and when he tries to Jew you down to two for a quarter, then it is time to show up your tintypes. Even then he will turn pale when you tell him four for seventy-five cents, and he will commence quoting the prices of all the other photographers within a radius of twenty

19. R. W. Hubbell, "Shall We Take Tintypes?" *Photographic Mosaics* 20 (1884): 64.

miles. Tintypes are cheap: for all *that*, there is money in them, and they do very well when kept in their proper place.[20]

The nineteenth-century photographic elite did work hard to keep tintypes in their place. And so, though they were made in abundance for over half a century, from 1856 to well past the turn-of-the-century, tintypes never achieved a reputation for anything very much except speed and cheapness. Those two characteristics are significant, however. As Heighway noted in 1881, both the rapidity and simplicity of the process "inspire the sitter with confidence, and do not give occasion for thought of the matter in hand." Tintype workers were just that, ordinary workers, and the mood in their studios was likely to be somewhat more relaxed than the rarified, off-putting atmosphere in city galleries. "There is, in fact, a free-and-easiness about the whole business," wrote Heighway, "which induces a pleasant expression and naturalness of position."[21]

Scovill and Adams's guide listed other advantages. Since tintypes could be produced quickly, customers came to see them as the first truly instantaneous picture, taken and finished while they waited. Not surprisingly, photographers who made them enjoyed being paid right away for their work. Moreover, the dull finish of the tintype could

20. Ibid.

21. Heighway, "The Ferrotype—How It Is Made," 81.

actually soften and flatter "marked faces," a considerable benefit for those scarred by disease or the vicissitudes of war. Oftentimes the tintype was the only kind of photograph that could satisfy clients, as when visitors "want to take pictures of their friends with them," or when a sitting is put off until the last moment, or when "one's desires to have the number of portraits taken limited, thus avoiding any clash between photographer and patron as to the ownership of the negatives." Finally, the "masses will have them made in quantity, because they may be had at a comparatively low price."[22]

Tintype operations came in a variety of sizes and shapes, from all-purpose studios offering a variety of photographic styles, to primitive outdoor setups involving one or two operators and a hand- or horse-drawn cart containing a complete supply of materials as well as a rudimentary darkroom. A photographer from St. Charles, Missouri, R. Goebel, called his patented photo-wagon a photoperipatetigraph and promised that with it the photographer "may hasten to make a picture of a corpse, a building, a boiler explosion, a parade, or anything else out of doors."[23] It could be pulled with ease by one person and was adaptable to any kind of photography. George Parke, a tintypist's assistant

22. *The Ferrotyper's Guide*, 8–9.

23. "Goebel's Photoperipatetigraph," *The Philadelphia Photographer* 4, no. 45 (September 1867): 277.

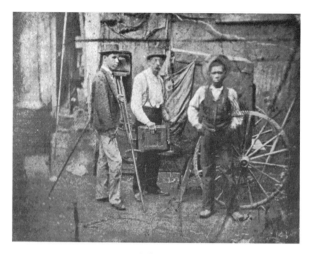

FIGURE 15. George Parke *(left)* with his tintypist employer and African American helper in a reproduction made from an original tintype and published in *Photo-Era Magazine*

for a brief period in the 1870s, worked with a similar outfit, though his was probably handmade. Parke and a young African American were employed by a Connecticut Yankee in an unnamed southern city, and he described his experiences in an article for *Photo-Era Magazine* in 1929.

We had a 5 × 7 wet-plate camera with one heavy holder, a sturdy and weighty tripod, and a pushcart in which the chemical manipulations were performed. This latter had two wheels, was fitted with a house-like body covered with oilcloth, and had a tarred tin tank for a bottom, a heavy curtain at the rear, and an orange-fabric window in front. The fittings were a keg and

spigot for washing water, shelves for trays, and bottles and a wood-encased glass-tank for the silver-bath.

Parke's main job was to serve as caller-out or solicitor, to march around town drumming up business, but his previous work as an apprentice in a portrait studio suggests that he also did some of the photography. The work was grueling, but enjoyable and entertaining as well. "We made pictures all day till the waning light forbade," he wrote, constructing a crude studio for each set of pictures. He would hold a large umbrella over the sitter "to dim the light's glare," especially in the middle of the day, and as always the "cringing victim's head" was firmly held in place by the "remorseless 'head-rest' of that period" since exposure times of fifteen or twenty seconds were routine. Due to the length of the exposures, snapshots were out of the question, and babies and small children "a terror to us and a poor source of income" since on more than one occasion he had to make ten exposures to obtain a single "passable" photograph. Parke finished his stint as a tintypist with an autumn sojourn in west Texas, where the group set up a tent-studio at a county fair on one day and the next narrowly avoided being shot by a group of hung-over cowboys hugely displeased with the previous day's pictures.[24]

24. George Parke, "The Tintype Photographer of the Seventies," *Photo-Era Magazine* 62 (1929): 194–5.

Charles Tremear, an unforgettable Buffalo Bill Cody lookalike with long white hair, moustache, and goatee who insisted that he was the last working tintypist in America, began his career as an itinerant in 1888, traveling around the Midwest in a horse-drawn "gallery on wheels." He used an average exposure time of eighteen seconds, always employed a sturdy head vise, and charged his patrons fifty cents for four images. These were made on a single plate by a camera affixed with four lenses, the most common and least expensive portrait camera on the market. In the 1920s, Tremear was invited to move his operation to a small studio in Henry Ford's carefully reconstructed Greenfield Village, where he made old-fashioned tintypes for tourists and Ford's "special visitors."[25]

Although nineteenth-century photographic journals were filled with well-intentioned advice concerning the proper methods of making portraits—how to extract the most suitable expression, how much of the body to reveal or hide, how to select the perfect background, how to construct and operate the biggest and best skylights, and what accessories and embellishments to include—the average

25. Samuel Childers, "Not on Your Tintype," *American Notes and Queries* 3, no. 8 (November 1943): 123. See also H. F. Morton, *Strange Commissions from Henry Ford* (York, Pa.: Herald Printing Works, ca. 1944), 66.

tintypist used a distinctly no-frills approach, allowing the patron to make crucial decisions as to pose and expression. Tintype subjects were most often shown sitting or standing against a plain burlap or canvas backdrop, staring either right into the camera or just off to one side or the other. The purpose of both tintypist and sitter was simple: to produce a reasonable likeness at low cost. Neither one was much interested in making an artistic statement, and so the various arcane rules and regulations of fine-art portrait photography were ignored. For well-born Victorians, the unenlightened informality of tintype photography amounted to apostasy, but for working stiffs it seemed natural and perhaps even somewhat comforting. In an indoor or outdoor tintype studio, patrons could relax a little, for there was no exalted upper-class esthete behind or beside the camera, sizing up the sitter with distaste and suggesting a series of unnatural poses. In tintyping, the photographer's hand was muted; oftentimes, in fact, the sitter created his or her own portrait.

That working-class people possessed vigorous ideas of their own about portraiture was another constant source of friction and misunderstanding. For some studio photographers it was simply inconceivable that poor people could or should make their own decisions about photography. Thus, H. J. Rodgers was highly amused by and contemptuous of the indignation of one churlish client who insisted on a full-

length portrait—boots and all—at a time when the head-and-shoulders cabinet picture reigned supreme. "Do yer s'-pose I'm going to pay as much money for half of me as for the whole of me?" the man asked, incredulous, adding that if he was only getting half a portrait he wanted half his money back. To make matters worse, the client also insisted on posing himself, dismissing entirely Rodgers's attempts to create a more artistic effect.[26]

Rodgers's scorn was not unique. In 1867 Boston photographer John S. Notman cautioned his colleagues that a "prevalent desire for cheapness" attracted the wrong kind of people into his beloved profession. Photography, he noted, required "expensive apparatus; a skillfully-constructed and well-lighted studio; pure, and therefore not cheap chemicals; and a practical and artistic knowledge of composition."[27] Notman's criticism, which seemed directed particularly at tintypists and their subjects, had no discernable impact on either the lives or work of the working-class folk who crowded into tintype studios; though mean-spirited and elitist, Notman was also irrelevant.

People who had been kept out of photography by the comparatively high cost of the first processes were finally

26. Rodgers, *Twenty-three Years Under a Skylight*, 92, 94.

27. "Cabinet Photographs," *Humphrey's Journal* 19, no. 7 (August 1, 1867): 207.

able to indulge in pictures once tintypes brought the prices down. Relatively few journeymen could have come up with the cost of a daguerreotype, for instance, for throughout the 1840s and 1850s working-class people had money only for the bare necessities. Horace Greeley's *New-York Daily Tribune*, a stalwart supporter of domestic industries and working men and women, reported in July 1845 that despite "an unusual degree of thrift and prosperity, growing and expanding on all sides," the ability of common laborers to eke out a living was unimproved; in some cases, it actually deteriorated. Simple laborers, wrote Greeley, made as little as a dollar a week, and even in skilled trades such as shoe-making weekly salaries had fallen so low during the 1840s that "the great mass of them work at rates which will hardly keep body and soul together." For women it was worse. The wages of those employed as seamstresses, bookbinders, and the like averaged about two dollars a week, but the work was seldom steady and outright destitution was the norm.[28] Outside of New York things were no better. In the iron industry, wages paid per ton of ore sank steadily from 1837 to 1858. Puddlers made on average $4.25 per ton in 1837, but only $1.90 to $2.50 a ton in 1858.[29]

28. "The Anarchy of Labor," *New-York Daily Tribune*, July 9, 1845, [2].

29. Norman Ware, *The Industrial Worker, 1840–1860* (Chicago: Quadrangle Books, 1964), 27.

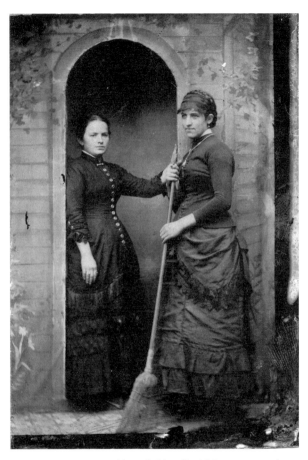

FIGURE 16. Tintype of household staff, with broom. From the Collection of Ken Heyman.

There was absolutely no way that these working people could have afforded a daguerreotype or even, in most cases, a less expensive carte de visite.[30]

The urge to secure a personal likeness was not new; what was different was that the tintype made it possible for a significant number of working-class Americans to participate for the first time in photography. They did so at a crucial time in history, for the nature of work itself and the lives of workers underwent an extraordinary transformation in the decades following the Civil War. From a nation made up primarily of independent shopkeepers, small-scale manufacturers, and subsistence farmers in 1850, the United States became by 1900 an industrial empire in which most people worked not for themselves but for corporations and other large businesses. Economic independence, self-sufficiency, and the primacy of craftsmanship remained cherished ideals, but real life increasingly meant long hours of routinized, semiskilled labor leading to a paltry weekly paycheck. At the end of the Civil War, America was mostly agrarian, and over half the work force was self-employed;

30. An exception to this was the creation by a very few companies of carte de visite albums consisting of portraits of individual workers posing with tools. See, for instance, Ronald Filippelli and Sandra Stelts, "Sons of Vulcan: An Iron Workers Album," *Shadow and Substance: Essays on the History of Photography*, ed. Kathleen Collins (Bloomfield Hills, Mich.: The Amorphous Institute Press, 1990).

by 1920, only about 20 percent of Americans worked for themselves, and fewer than 12 percent worked on farms.[31] What the occupational tintype portrait did was to memorialize the individual at precisely the time that the workplace was becoming hugely impersonal, and labor a thing to be carefully measured, standardized, and ultimately controlled by an army of implacable efficiency experts answering only to management.

That working people once chose to pose with the tools of their trade is not surprising, though it is not done much any more, at least not in a formal sense. Nineteenth-century worker portraits, especially the humble tintype variety, symbolize the inherent dignity of work and the inevitability of progress and prosperity; they celebrate what Ronald Filippelli and Sandra Stelts rightly call the "lofty status of the skilled worker in mid-nineteenth century America."[32] But George Eastman's Kodak cameras, and especially their less expensive progeny, the Brownies, made trekking to the local photographer's studio with a set of tools unnecessary, and people slowly stopped doing it after 1888. In the twentieth century, as the country became increasingly oriented

31. Melvyn Dubofsky, *Industrialism and the American Worker, 1865–1920*, 2nd ed. (Arlington Heights, Ill.: Harlan Davidson, Inc., 1985), 3.

32. Filippelli and Stelts, "Sons of Vulcan," 105, 107.

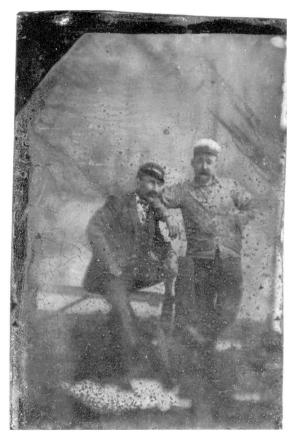

FIGURE 17. Tintype of two friends in a makeshift tintype
studio. From the Collection of Ken Heyman.

to the consumption of goods rather than their production, workers were far more likely to pose informally with their toys instead of with their tools, and the images were almost always made by a relative or friend and processed and printed by automated machine.

The heyday of the tintype was brief, but it left us with remarkable images of people who were proud of their work, of the tools they used, and of the things they made, proud even of their place in society. It is appropriate that we pay homage to them.

Tintype Gallery

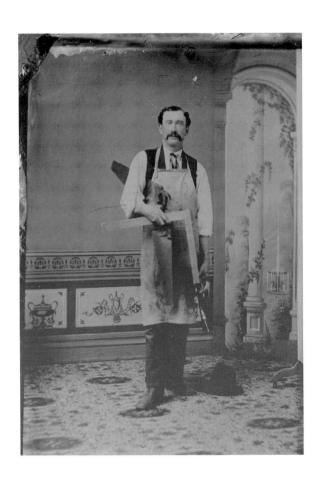

PLATE I
Carpenter

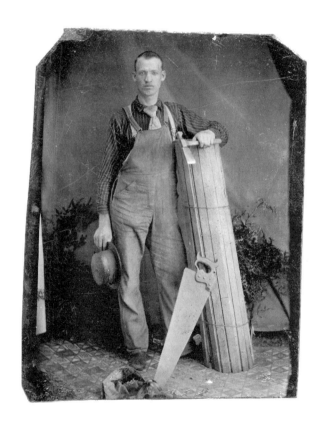

PLATE 2
Carpenter with lathing hatchet, bundle of lathing strips,
and handsaw

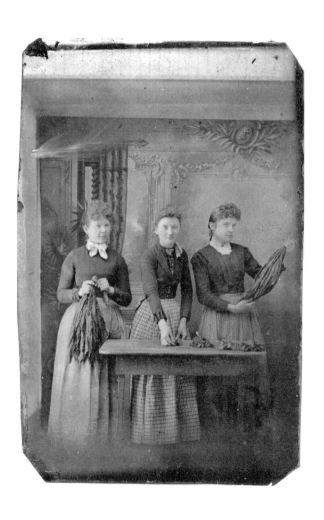

PLATE 3
Tobacco workers

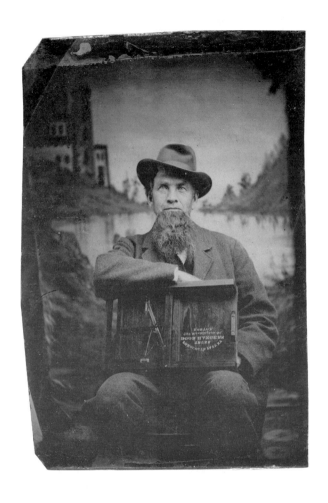

PLATE 4 *(above)*
Man with patent model for barn door operating system,
held upside down

PLATE 5 *(right)*
Bartender

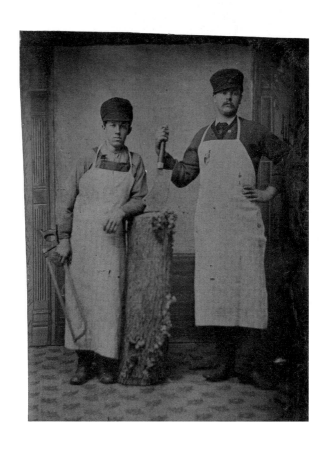

PLATE 6
Butchers

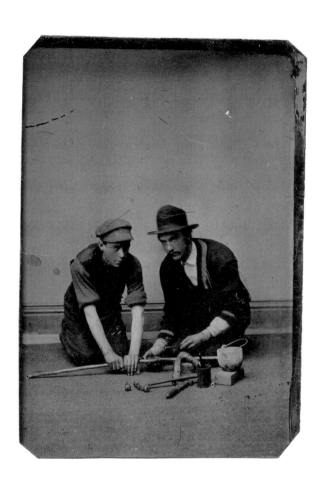

PLATE 7
Pipe fitters with hammers, cutting tools, and soldering equipment

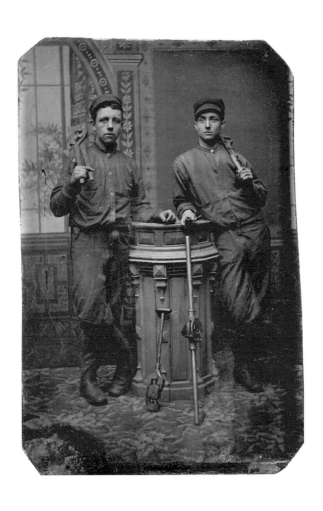

PLATE 8

Plumbers posing with wrenches, a pipe cutter,
and pipe-threading die stock

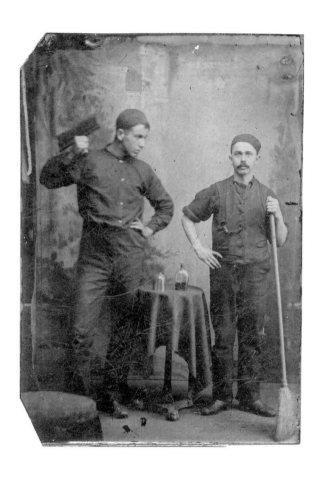

PLATE 9
Paperhangers

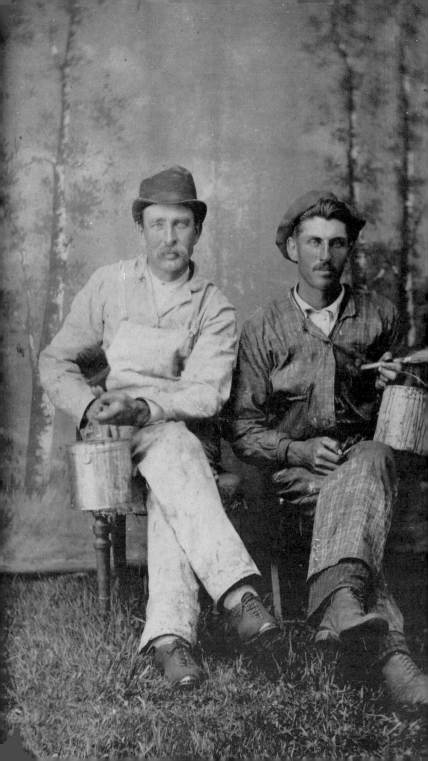

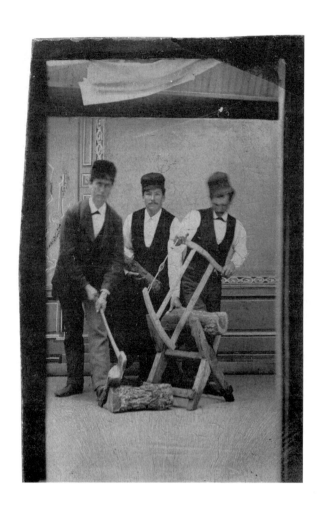

PLATE 10 *(left)*
Housepainters

PLATE 11 *(above)*
Men with broad axe and bucksaw

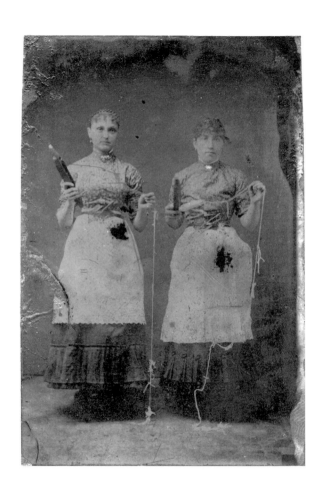

PLATE 12
Textile workers with spindles and yarn

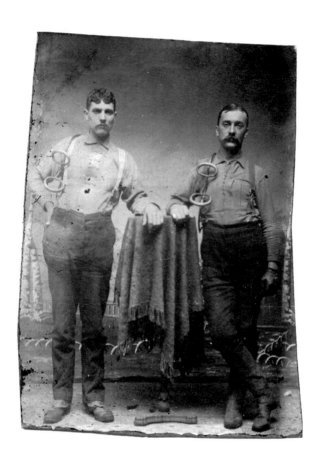

PLATE 13
Icemen with tongs

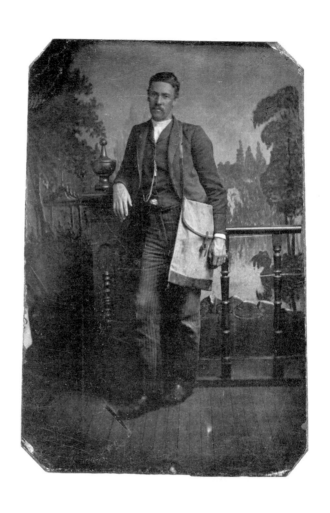

PLATE 14
Messenger

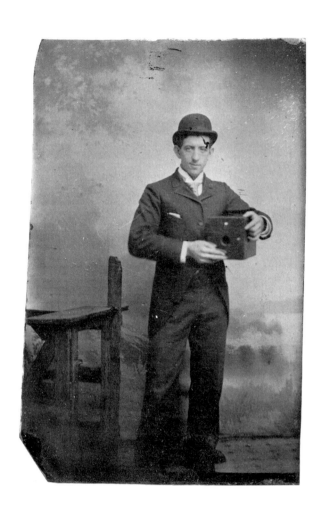

PLATE 15
Man with camera

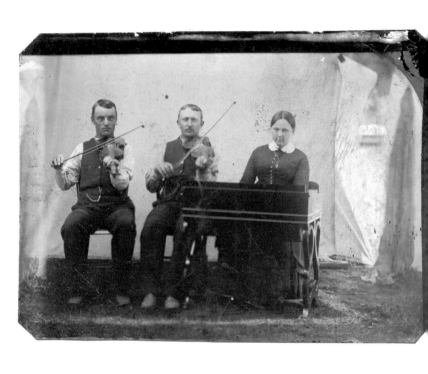

PLATE 16

Family of musicians. The woman is playing a reed organ.

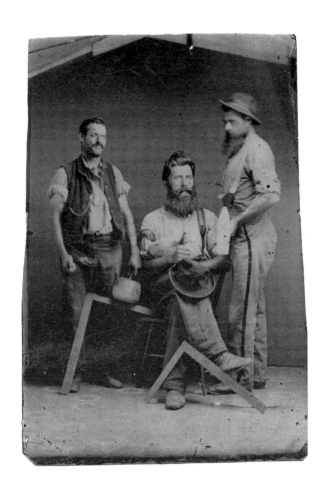

PLATE 17

Stonecutters

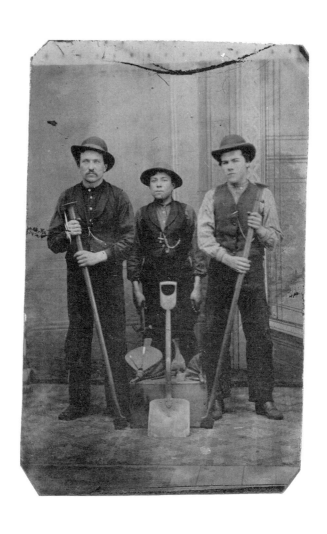

PLATE 18
Furnace cleaners

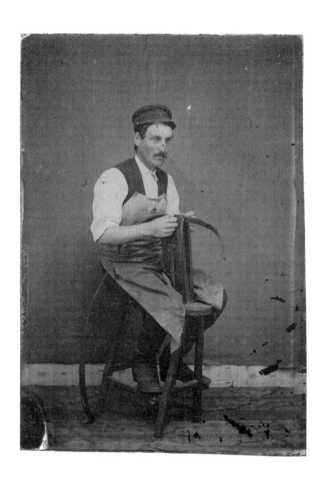

PLATE 19
Harness maker

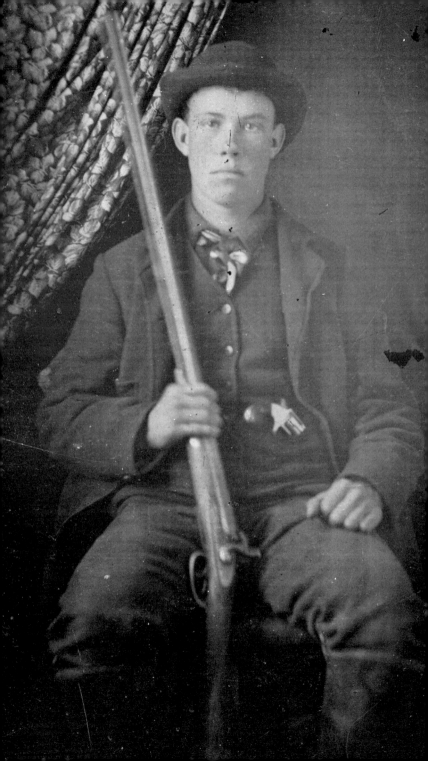

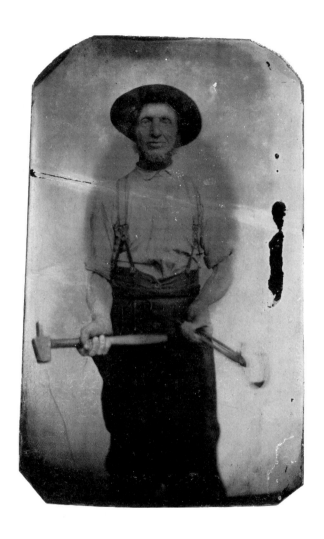

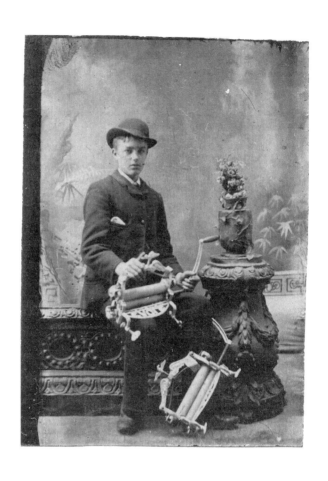

PLATE 22
Salesman with samples of fancy clothes mangles

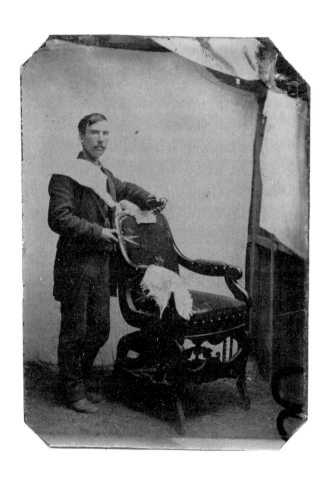

PLATE 23
Barber

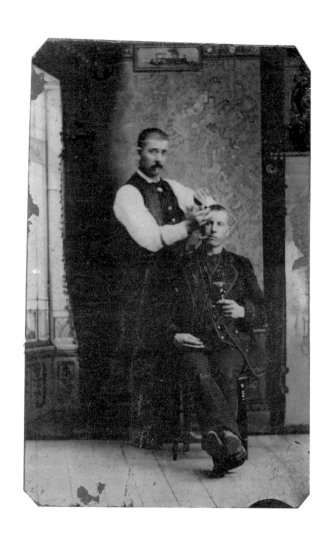

PLATE 24
Barber and client

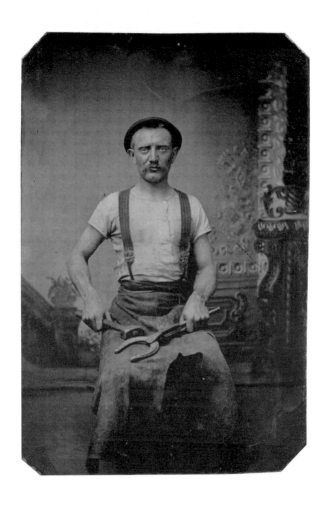

PLATE 25

Farrier

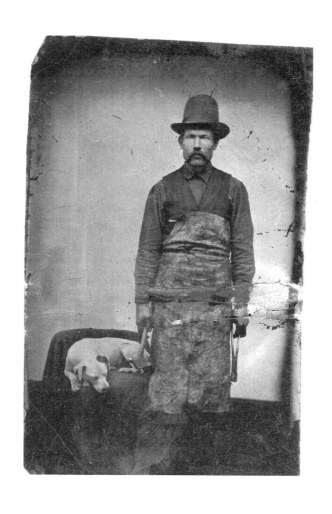

PLATE 26
Blacksmith with hammer, tongs, and dog

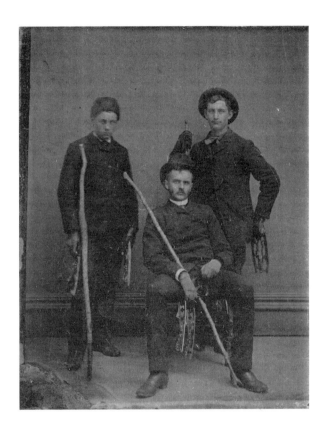

PLATE 27
Skating rescue team. The sticks are to assist people who have
fallen through the ice.

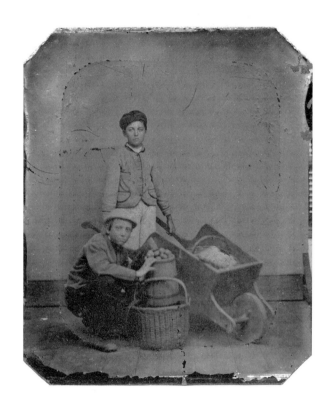

PLATE 28
Fruit and vegetable peddlers

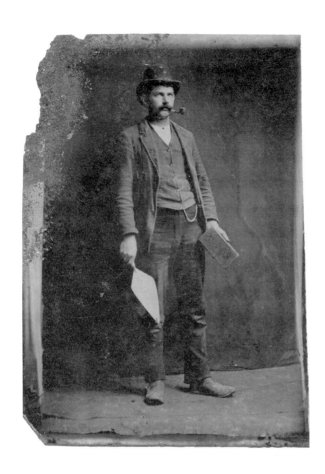

PLATE 29
Bricklayer

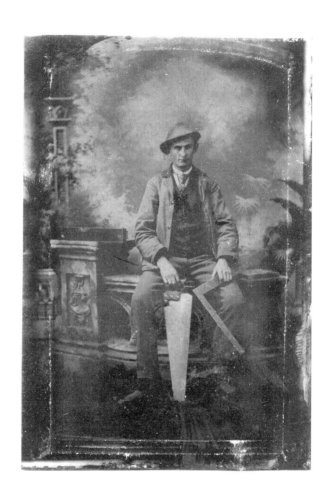

PLATE 30
Carpenter

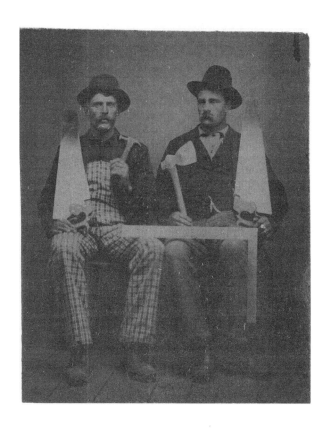

PLATE 31
Carpenters

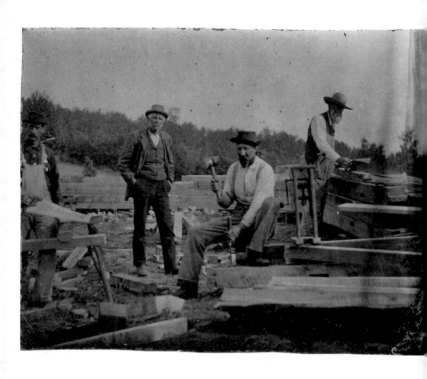

PLATE 32 *(above)*

Timber framers at work with heavy mortising chisel and timber-
boring machine. The man wearing the suit and vest is either the
foreman or owner.

PLATE 33 *(right)*

Marching-band member with cornet

⟵ 88 ⟶

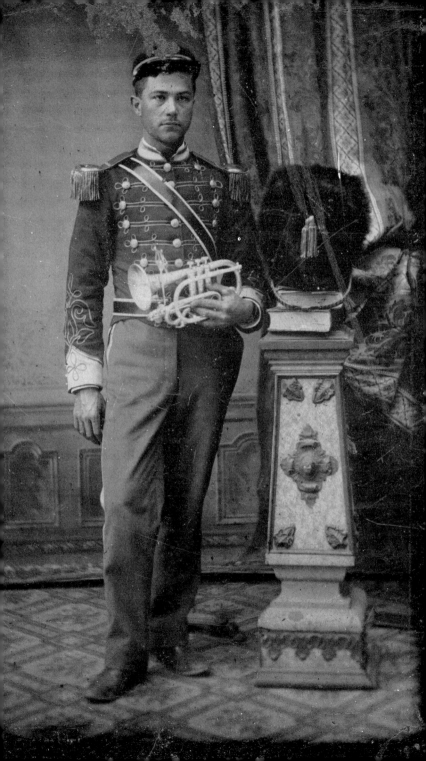

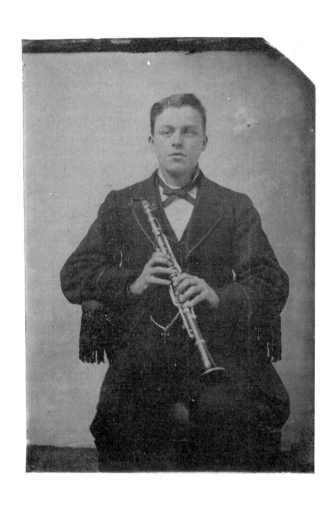

PLATE 34
Clarinetist

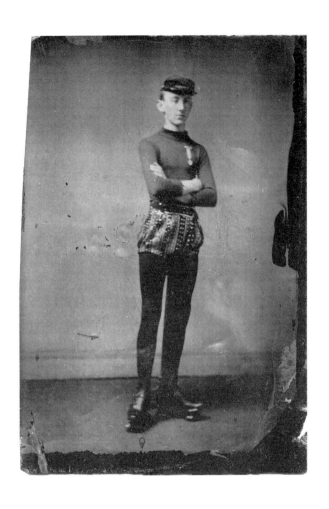

PLATE 35
Roller skates performer or racer

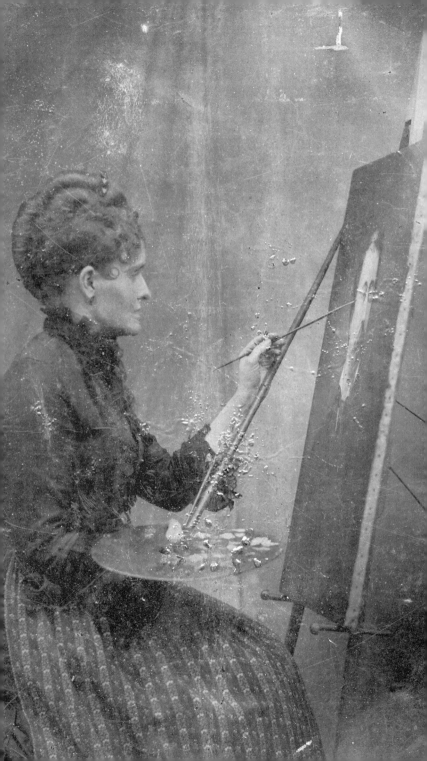

PLATE 36 *(left)*
Portrait painter with mahlstick to steady the hand

PLATE 37 *(above)*
Textile mill worker

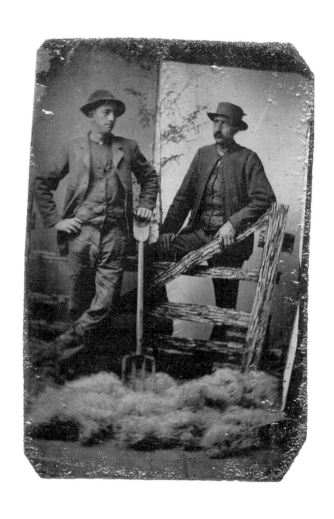

PLATE 38
Men with pitchfork

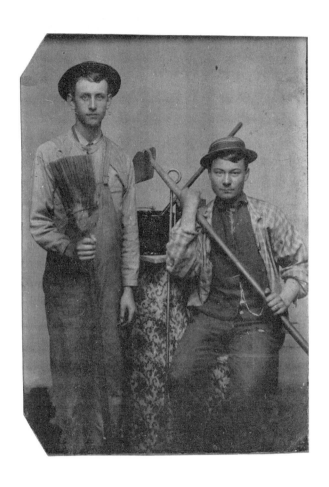

PLATE 39

City storm drain cleaners

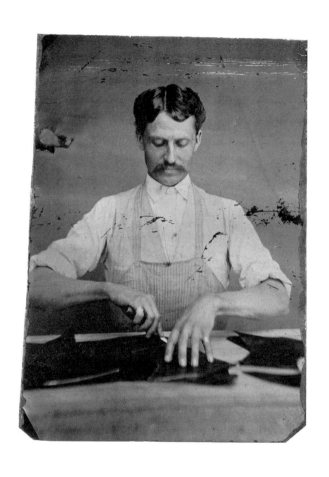

PLATE 40
Leather worker

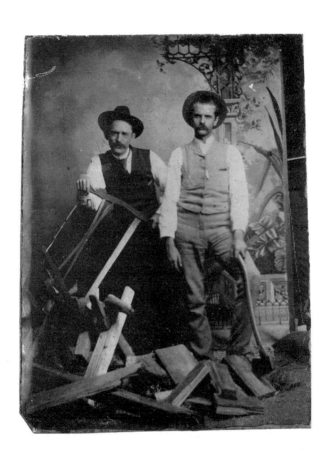

PLATE 41

Men with axe and bucksaw

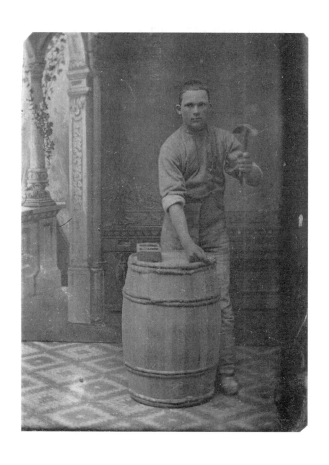

PLATE 42
Barrel maker holding a cooper's adz with barrel for dry goods

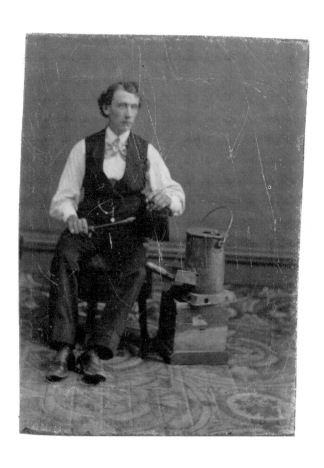

PLATE 43
Metal worker holding a copper with sheet metal
soldering iron heater

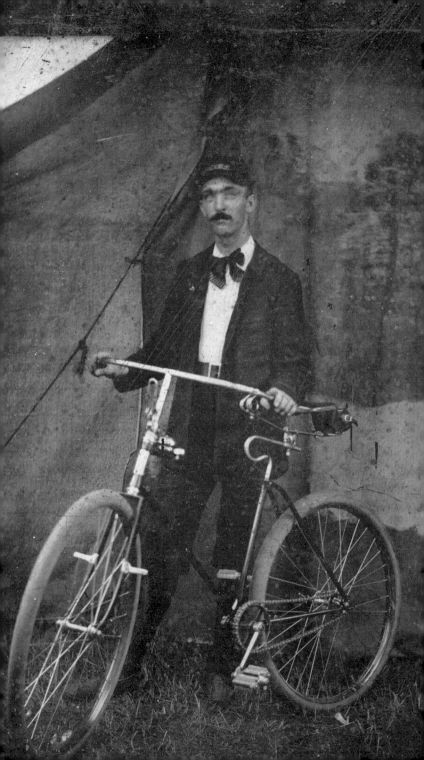

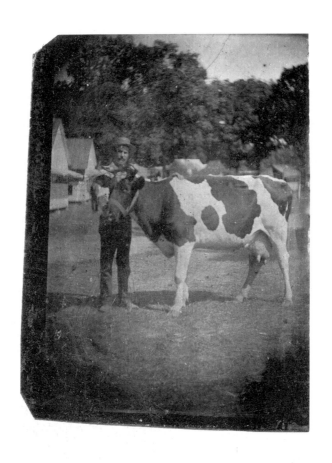

PLATE 44 *(left)*
Deliveryman with 1890s safety bicycle

PLATE 45 *(above)*
Farmer with milk cow

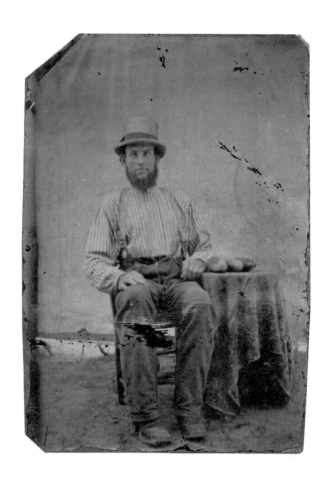

PLATE 46
Farmer with produce

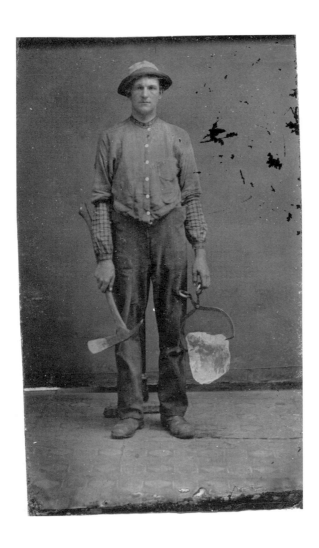

PLATE 47
Iceman

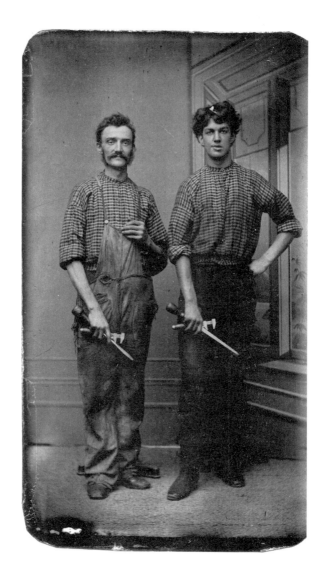

PLATE 48
Mechanics with Coe's nut wrenches and screwdrivers

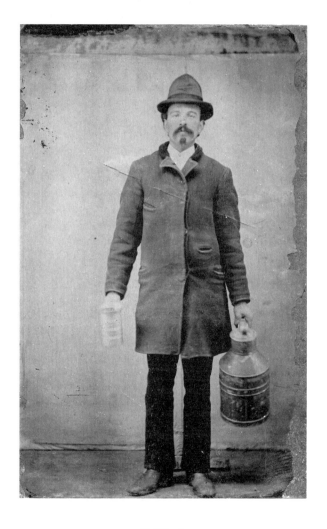

PLATE 49
Milkman

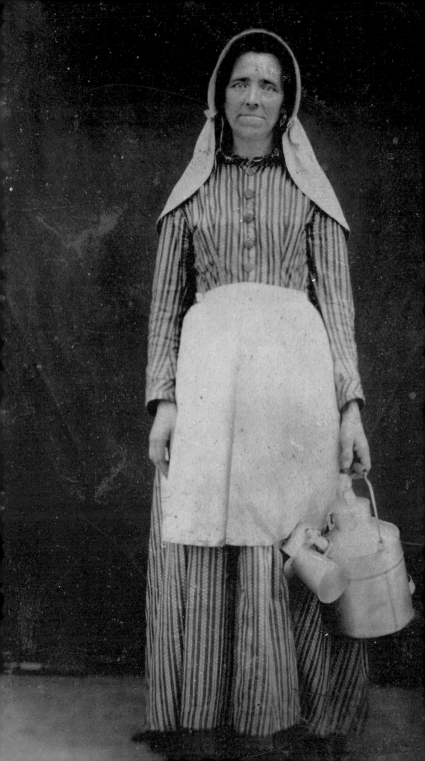

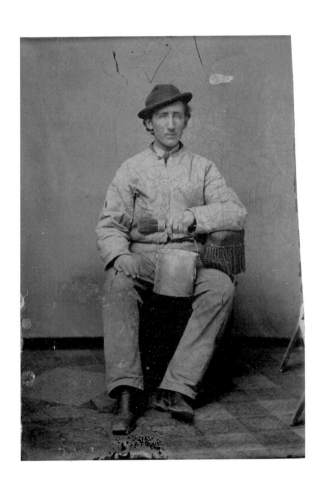

PLATE 50 *(left)*
Milkmaid

PLATE 51 *(above)*
Housepainter

PLATE 52
Housepainter

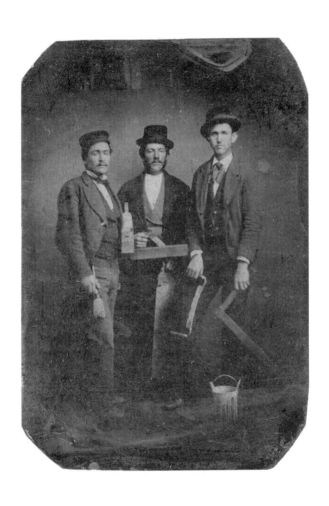

PLATE 53

Men with bench plane, draw knife, framing square,
and a can of paint

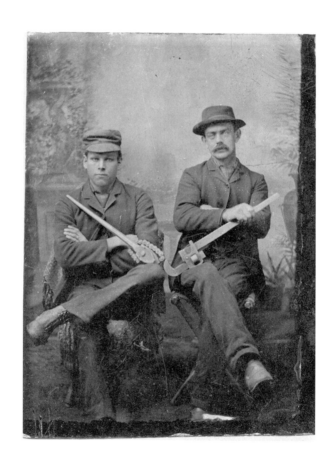

PLATE 54
Plumbers with chain wrench *(left)* and Stillson wrench *(right)*

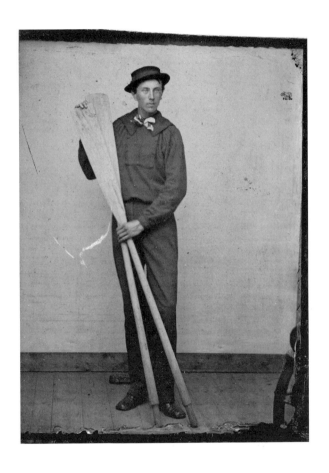

PLATE 55
Oarsman

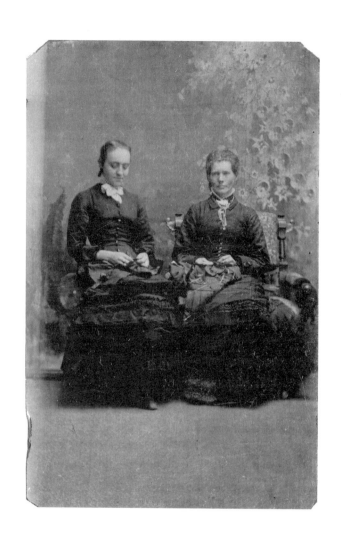

PLATE 56
Dressmakers

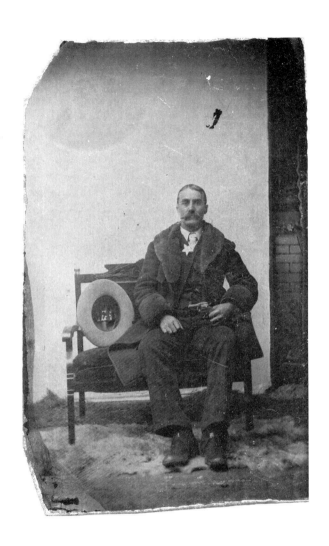

PLATE 57
Law man

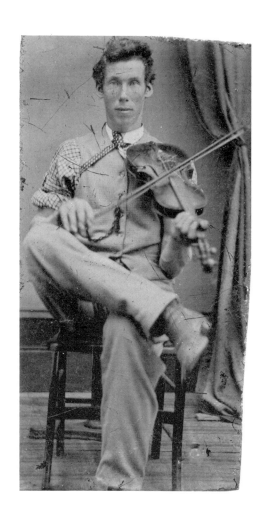

PLATE 58
Fiddler

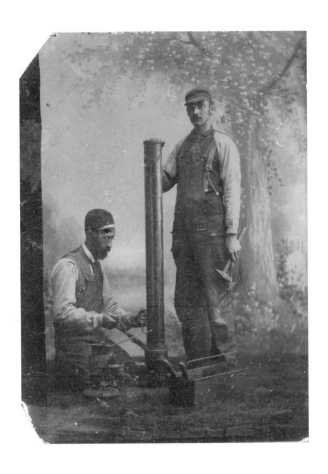

PLATE 59
Metal workers. The kneeling man is holding soldering equipment.

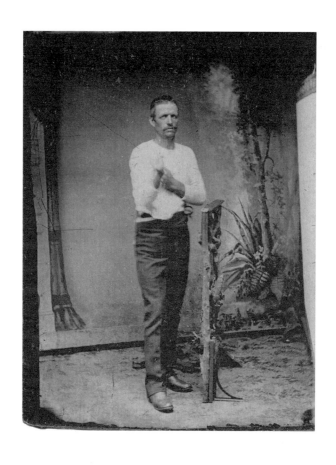

PLATE 60
Bare-knuckle boxer

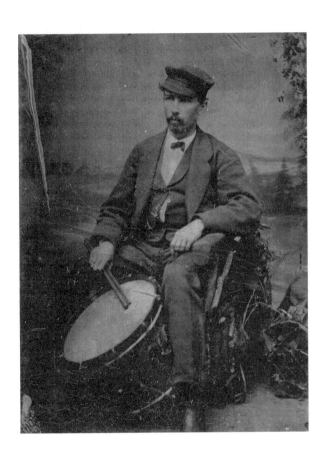

PLATE 61
Drummer

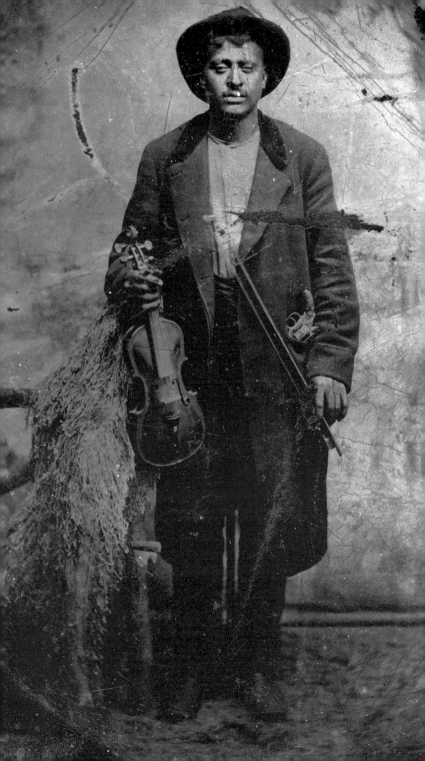

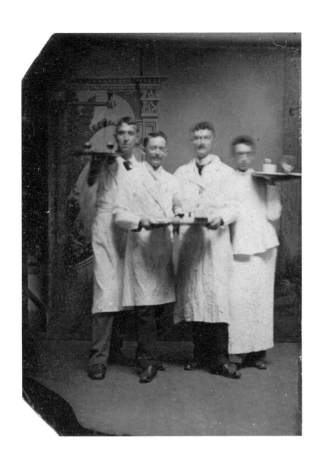

PLATE 62 *(left)*
Man with violin and pistol; both may be studio props.

PLATE 63 *(above)*
Waiters

⊷119⊷

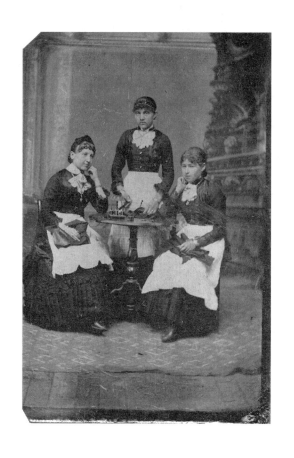

PLATE 64

Seamstresses

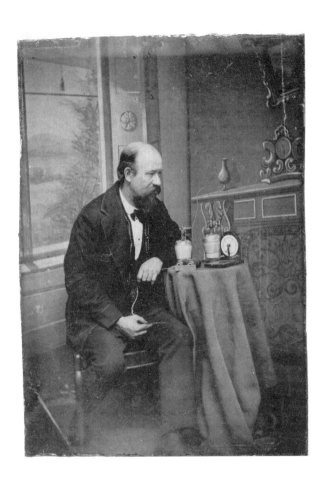

PLATE 65
Experimenter with electrical device

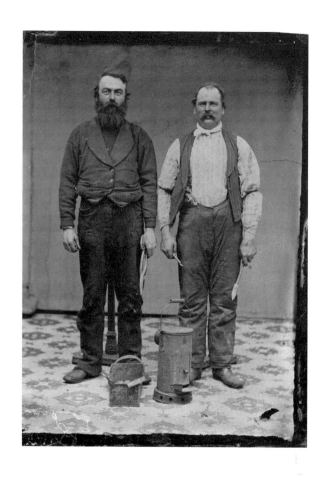

PLATE 66
Tinsmiths

Selected Bibliography

Borthwick, John D. *The Gold Hunters: A First-Hand Picture of Life in California Mining Camps in the Early Fifties.* Oyster Bay, N.Y.: Nelson Doubleday, 1917.

Collins, Kathleen, ed. *Shadow and Substance: Essays on the History of Photography.* Bloomfield Hills, Mich.: The Amorphous Institute Press, 1990.

Crampton, Frank. *Deep Enough: A Working Stiff in the Western Mine Camps.* Norman, Okla.: University of Oklahoma Press, 1982.

Davis, James J. *The Iron Puddler.* New York: Grosset and Dunlop, Publishers, 1922.

Dubofsky, Melvyn. *Industrialism and the American Worker, 1865–1920.* 2nd ed. Arlington Heights, Ill.: Harlan Davidson, Inc., 1985.

Estabrook, Edward M. *The Ferrotype and How to Make It.* Cincinnati, Ohio, and Louisville, Ky.: Gatchell and Hyatt, 1872.

The Ferrotyper's Guide. New York: Scovill and Adams Company, 1896.

Gordon, Robert B., and Patrick M. Malone. *The Texture of Industry: An Archaeological View of the Industrialization of North America.* New York: Oxford University Press, 1994.

Jenkins, Reese V. *Images and Enterprise: Technology and the American Photographic Industry, 1839–1925.* Baltimore, Md.: Johns Hop-

kins University Press, 1975.

Kasson, John F. *Civilizing the Machine: Technology and Republican Values in America, 1776–1900*. New York: Penguin Books, 1977.

Laurie, Bruce. *Artisans into Workers: Labor in Nineteenth-Century America*. New York: The Noonday Press, 1989.

Montgomery, David. *The Fall of the House of Labor*. New York: Cambridge University Press, 1996.

———. *Workers' Control in America: Studies in the History of Work, Technology, and Labor Struggles*. Cambridge: Cambridge University Press, 1979.

Morton, H. F. *Strange Commissions from Henry Ford*. York, Pa.: Herald Printing Works, ca. 1934.

Nelson, Daniel. *Frederick W. Taylor and the Rise of Scientific Management*. Madison, Wisc.: University of Wisconsin Press, 1980.

Nordstrom, Alison. "Voyages (per)Formed: Photography and Travel in the Gilded Age." Ph.D. diss., Union Institute, 2001.

Rinhart, Floyd, Marion Rinhart, and Robert W. Wagner. *The American Tintype*. Columbus, Ohio: Ohio State University Press, 1999.

Rodgers, H. J. *Twenty-three Years Under a Skylight*. Hartford, Conn.: H. J. Rodgers, Publisher, 1872; New York: Arno Press, 1973.

Rorabaugh, W. J. *The Craft Apprentice: From Franklin to the Machine Age in America*. New York: Oxford University Press, 1986.

Ryder, James F. *Voigtlander and I in Pursuit of Shadow Catching*. Cleveland, Ohio: Cleveland Printing and Publishing Company, 1902.

Schlereth, Thomas J. *Artifacts and the American Past*. Nashville, Tenn.: American Association for State and Local History, 1989.

Severa, Joan. *Dressed for the Photographer: Ordinary Americans and Fashion, 1840–1900*. Kent, Ohio: Kent State University Press, 1995.

The Silver Sunbeam: A Practical and Theoretical Text-Book on Sun Drawing and Photographic Printing: Comprehending All the Wet and Dry Processes at Present Known. New York: Joseph H. Ladd, Publisher, 1864; Hastings-on-Hudson, N.Y.: Morgan and Morgan, Inc., 1969.

Sobieszek, Robert A. *The Collodion Process and the Ferrotype: Three Accounts, 1854–1872*. New York: Arno Press, 1973.

Taft, Robert. *Photography and the American Scene: A Social History, 1839–1889*. New York: Macmillan, 1938; New York: Dover Publications, Inc., 1964.

Talbot, George. *At Home: Domestic Life in the Post-Centennial Era, 1876–1920*. Madison, Wisc.: State Historical Society of Wisconsin, 1976.

Terkel, Studs. *Working*. New York: Pantheon Books, 1972.

Thomas, Alan. *Time in a Frame: Photography and the Nineteenth-Century Mind*. New York: Schocken Books, 1977.

Trachtenberg, Alan. *The Incorporation of America: Culture and Society in the Gilded Age*. New York: Hill and Wang, 1982.

Wallace, Elizabeth. *Mark Twain and the Happy Island*. 2nd ed. Chicago: A. C. McClurg and Co., 1914.

Ware, Norman. *The Industrial Worker, 1840–1860*. Chicago: Quadrangle Press, 1964.

Warner, Sam Bass. *The Private City: Philadelphia in Three Periods of Its Growth*. Philadelphia, Pa.: University of Pennsylvania Press, 1968.

Werge, John. *The Evolution of Photography*. London: Piper and Carter, 1890.

Index